The Year of the Dog: 52 Weeks of Memphis

KATHRYN WILLIS & A RESCUE NAMED LOKI

Copyright © 2015 by Kathryn Willis
All Rights Reserved

First printing, 2015

Cover Photography Copyright 2014 by Kathryn Willis
Photographs of Kathryn and Loki by Phillip Van Zandt Photography

ISBN: 978-0-692-54169-2

Published by Kathryn Willis

All rights reserved. This book or any portion thereof may not be reproduced or used in any manner whatsoever without prior written permission from the publisher except in the case of brief quotations embodied in critical articles and reviews.

To Memphis for giving me Loki.

Acknowledgements

Thank you to Loki, for being my first dog and the most patient pup I know. You put up with a lot in the name of photography and are always game for anything as long as it involves peanut butter.

The wonderful people at the following locations: Mud Island River Park, Autozone Park, The Peabody Hotel, Memphis Botanic Garden, The Booksellers at Laurelwood, FedEx Forum and the Memphis Grizzlies, The Orpheum Theatre, Graceland, Amurica, Muddy's Bake Shop, Choose901, and Tart. Your willingness and enthusiasm to help us complete this project was invaluable. Thank you for taking a chance on this girl and her dog!

Doctors William Widdop, Jon Romines, Wendy Wolverton, Angie Zinkus and the staff of Germantown Parkway Animal Hospital. You are the best co-workers and have supported this venture through and through. Thank you for teaching me so much, for providing Loki with world-class care, and for becoming my Memphis family.

My Dad, for first putting a camera in my hands and teaching me how to use it. And my Mom, who has always encouraged all of my artistic forays throughout my life.

Caitlin L. Horton, my graphic designer extraordinaire and Whitney Worden, my editor supreme.

Austin King, for being my biggest supporter, my sounding board, my idea machine, Loki's treat holder, our chauffeur, and our problem solver. Your encouragement and faith in me has been unmatched; I couldn't have done it without you.

A special thanks to the fans of this project on Facebook. No matter when you started following along with us, you have been a great audience and community. I hope that you have enjoyed this project as much as we have enjoyed making it!

Finally, thank you to Memphis. You are a city full of grit and grind - a little rough around the edges and full of hidden gems. You have so much to offer to those who want to get to know you better. Thank you for always surprising me with your tenacity and for becoming my adopted home.

Introduction

The idea to create a 52 week photo project came about in 2014 as I was looking to find ways to both improve my photography skills and get to know Memphis a little better. As a transplant from New York, I love wandering through Memphis and finding neat side streets, works of street art, and seeing different angles of famous sites. Usually at my side through these explorations is my dog, Loki.

I adopted Loki in 2010 from an area rescue group who pulled him from Memphis Animal Services - a shelter with one of the highest euthanasia rates in the United States. He came to me sick and a bit scruffy, but over time he's blossomed into a handsome, talented, and bearded wonder-dog. Armed with a pocket full of treats and coupled with an unending eagerness from him, Loki has learned a variety of tricks and has perfected the doggy version of "Blue Steel" for photos.

Deciding to combine my love for photography, Loki, and Memphis, I set out to challenge myself to take one photo of Loki, once a week, at a different location in Memphis, for an entire year. This meant that we were dodging elements like intense heat, ice, snow, and rain as well as finding the right light at the right time of day all before the week's end. The final photo was taken on one of the coldest days of the year, but through it all Loki was a steadfast trooper.

The following photographs are the culmination of a year gone by set to the backdrop of both frequented and lesser-known places in Memphis. Each week's photo forms a unique little love letter to the place Loki, I, and many others call home. My hope for this project is for others to view Memphis from a different angle, as I have. Whether you are someone who has lived here your entire life or a visitor looking for what Memphis has to offer, I hope that Loki and I can encourage you to explore some of the great places that make up Memphis with fresh eyes, a sense of humor, and an open heart.

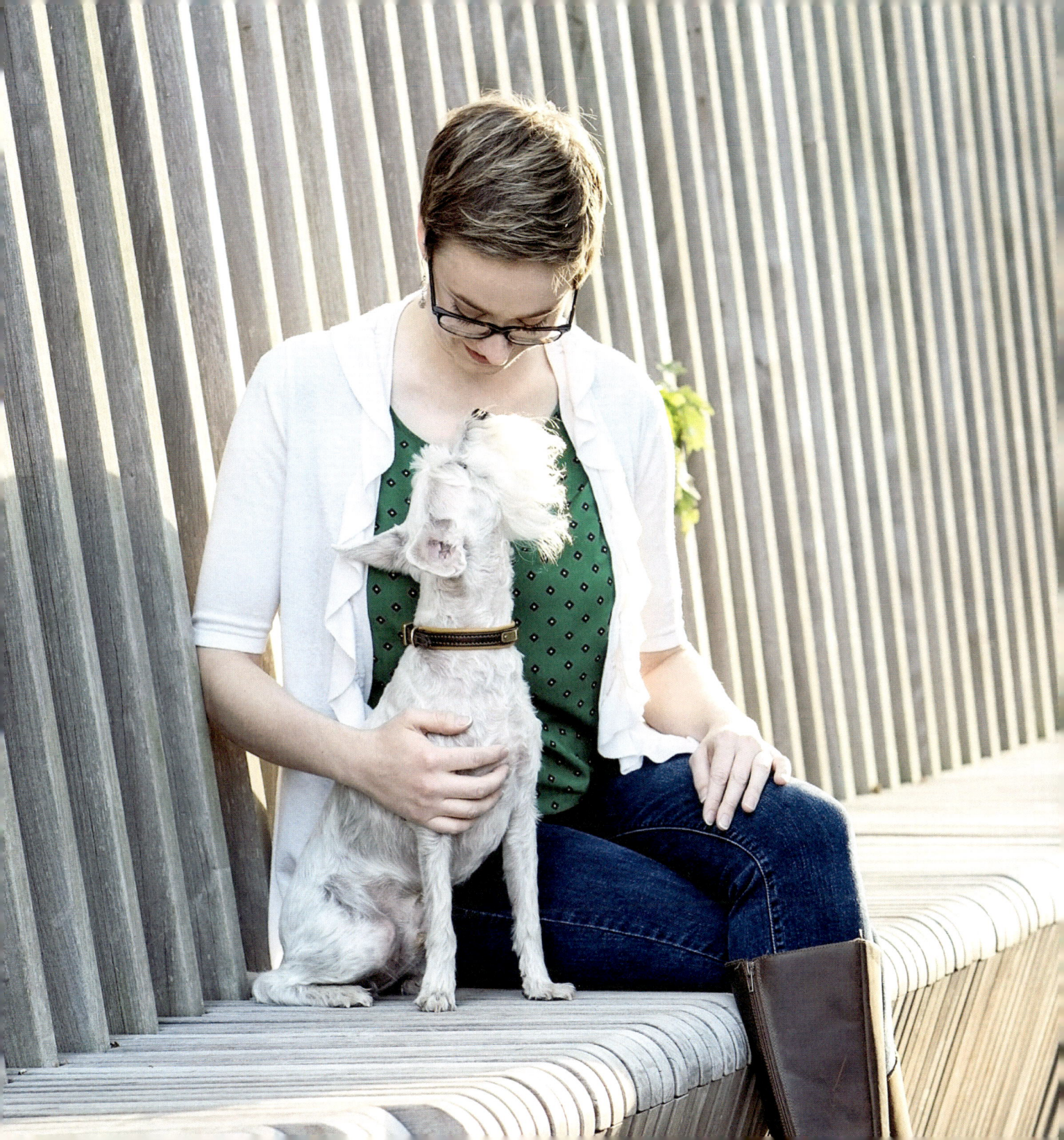

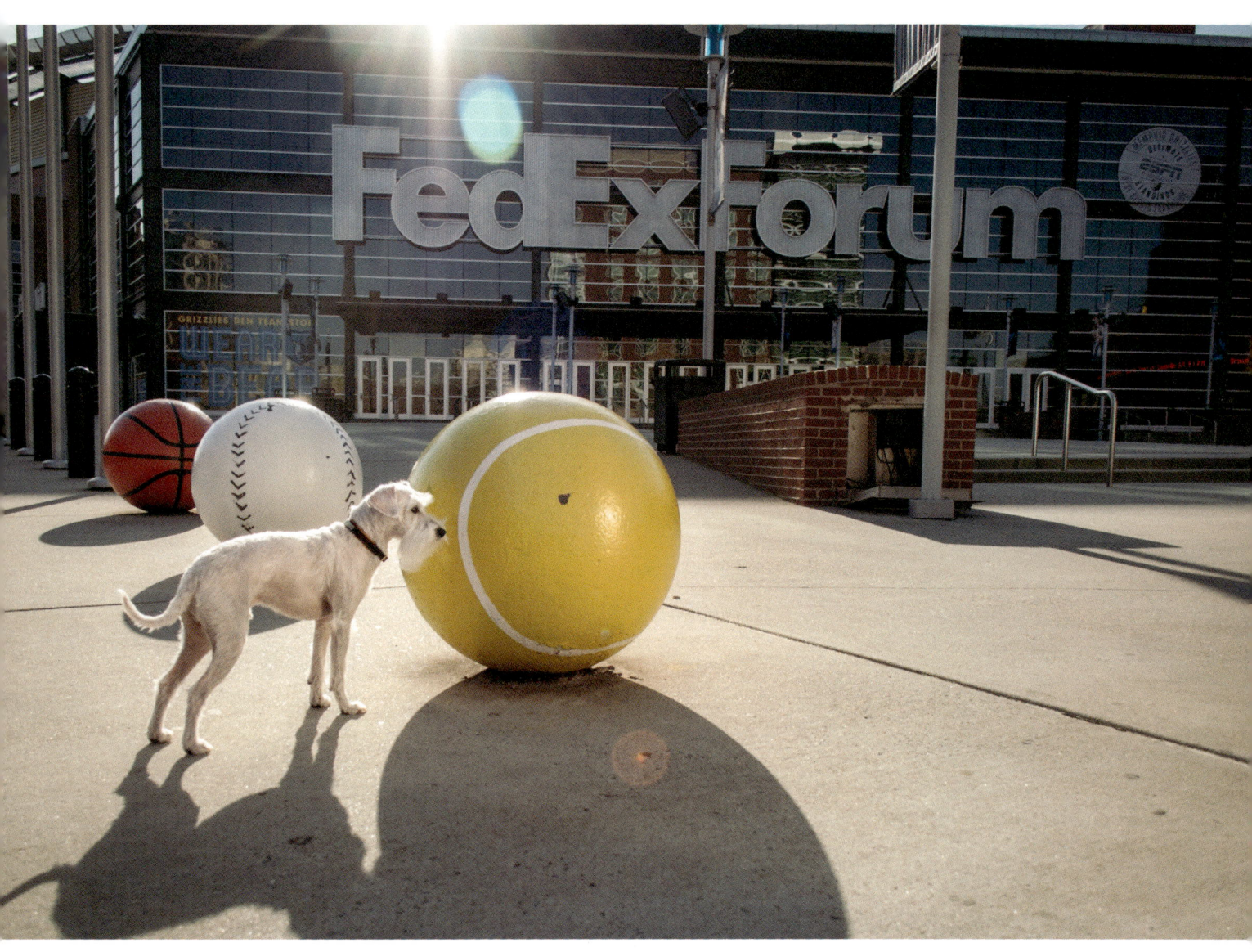

Week One

FEDEX FORUM

Week Two

LEVITT SHELL

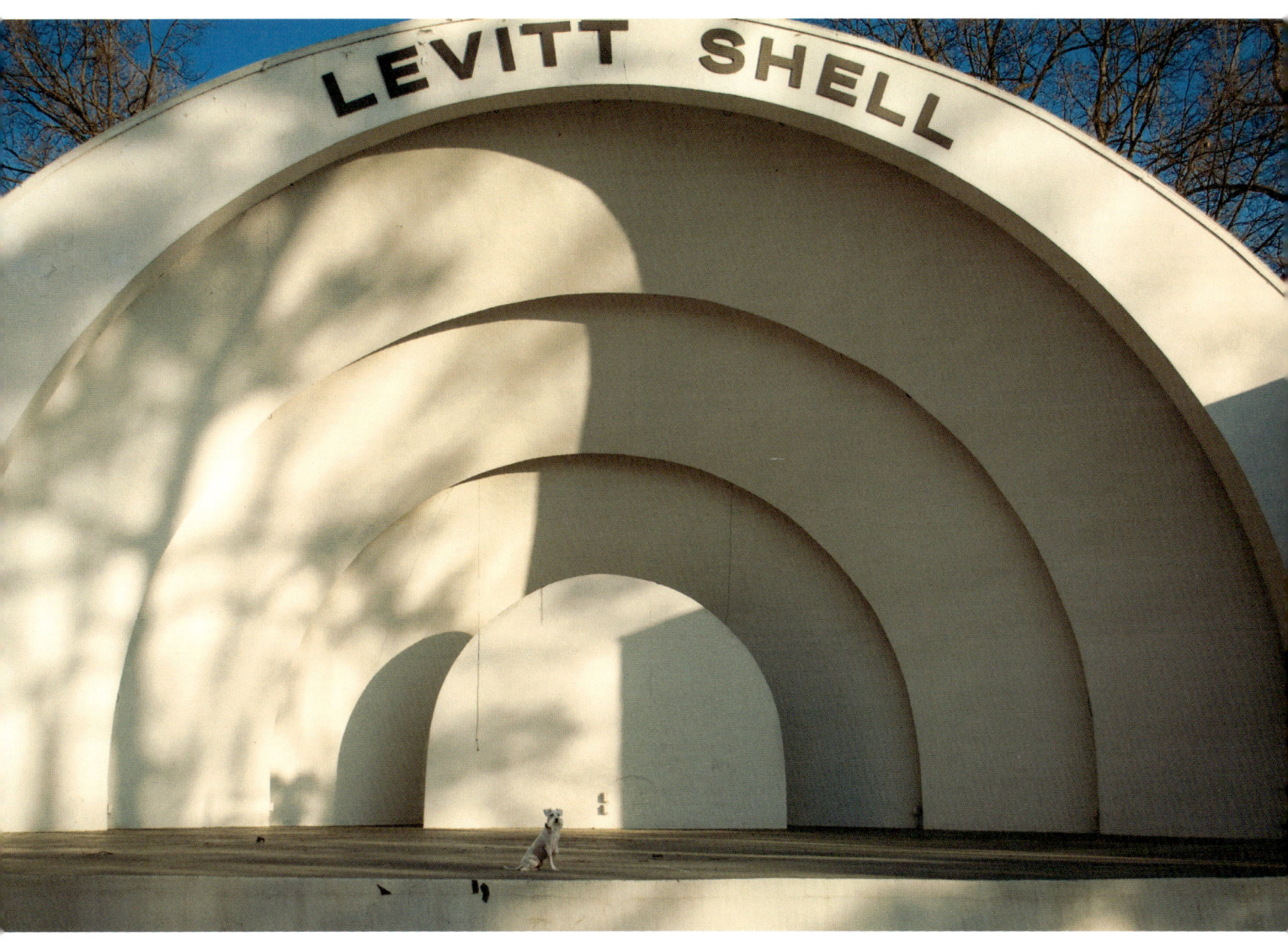

Week Three

JOE'S WINE AND LIQUORS

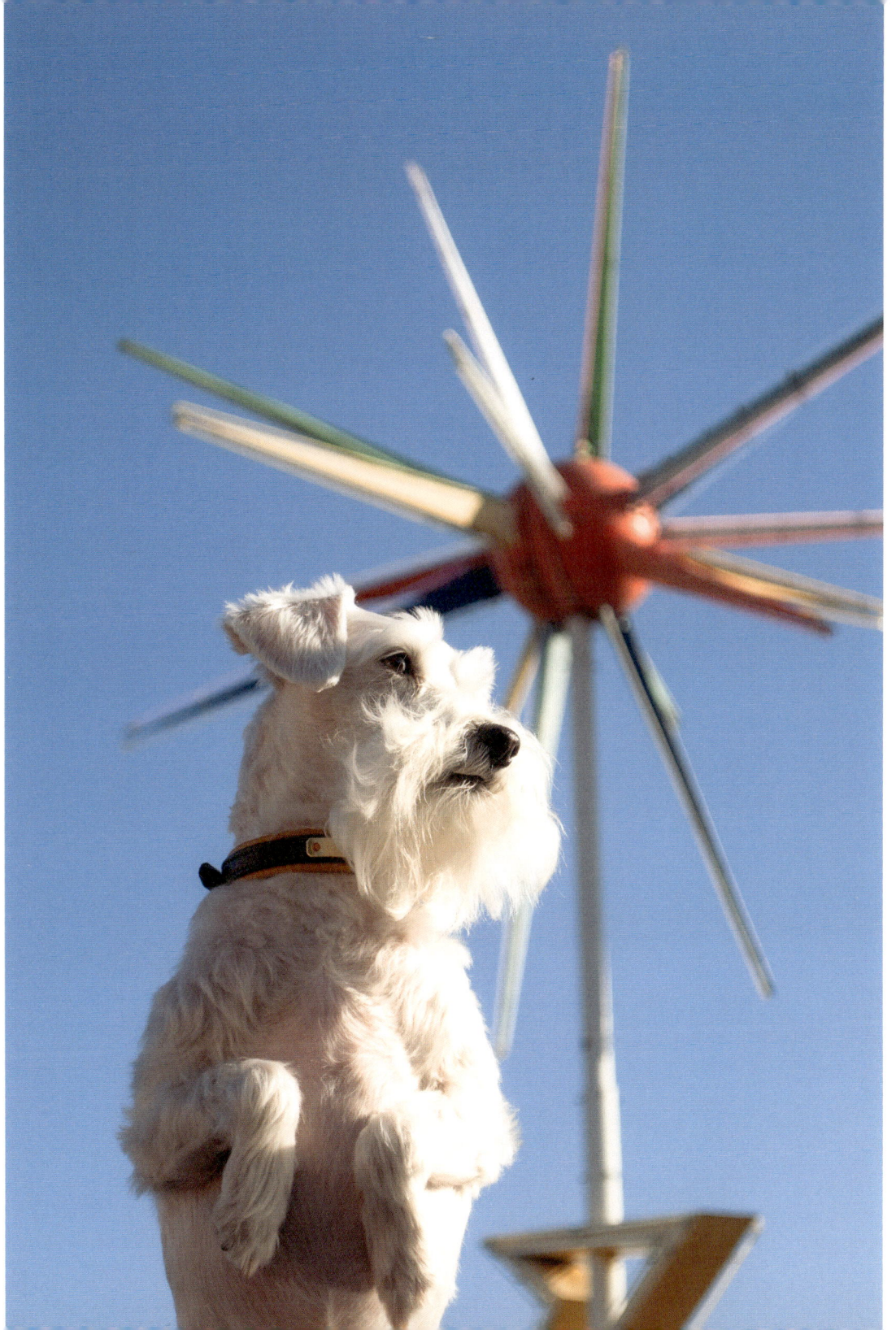

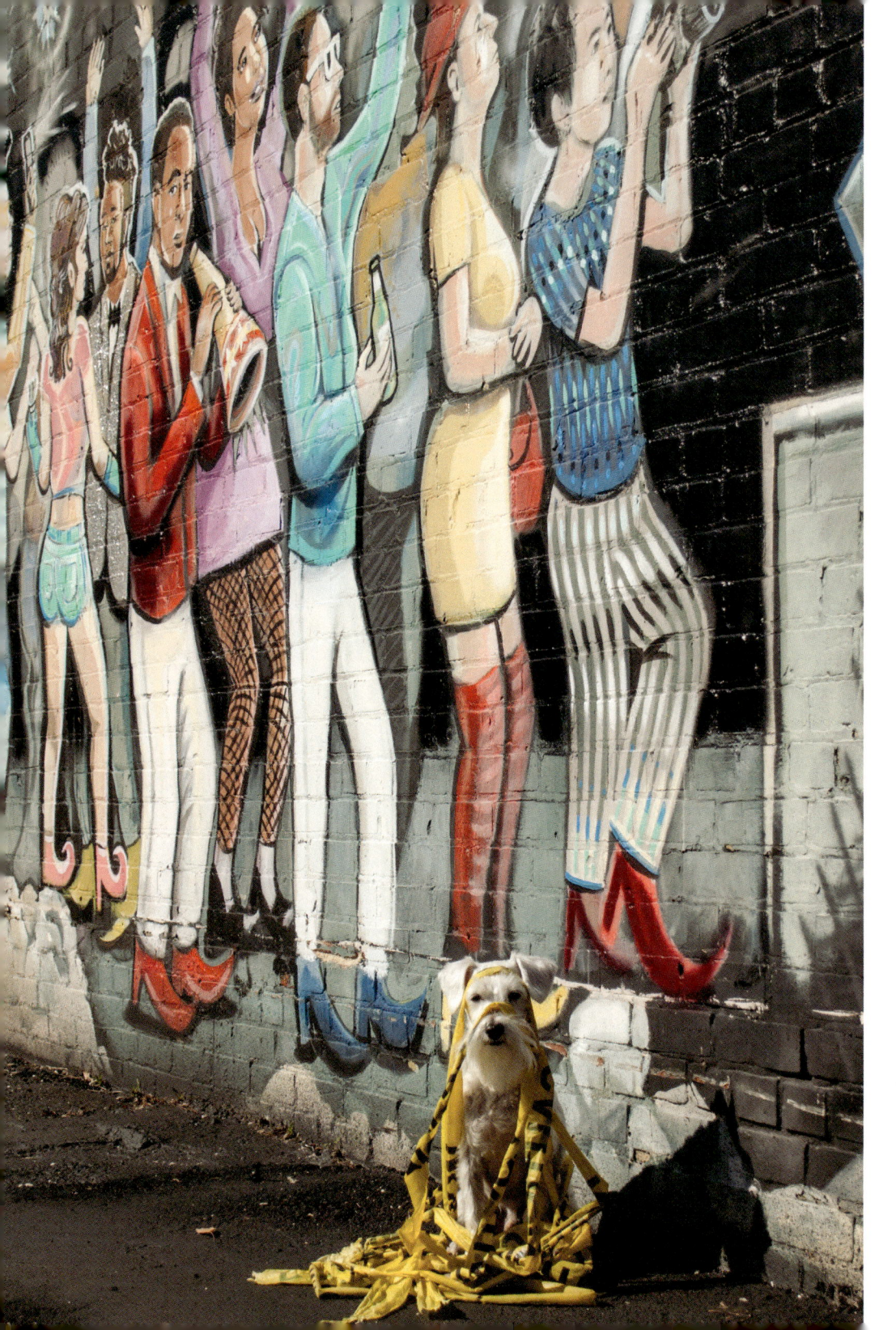

Week Four

OLD HI-TONE CAFE
1913 POPLAR AVE.

Week Five

'LIGHTSPAN' INSTALLATION
COURT AVE. AT FRONT ST.

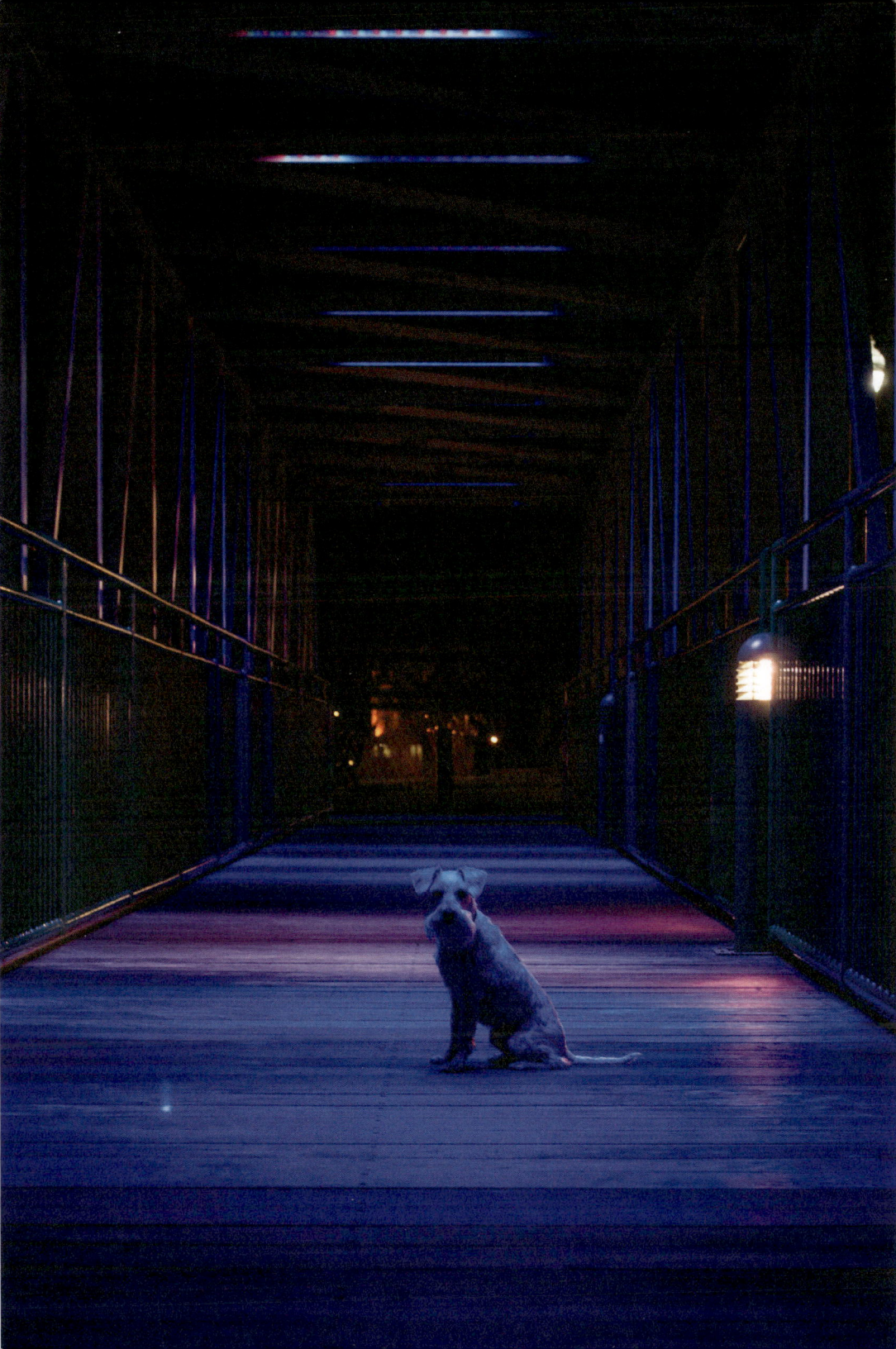

Week Six

MEMPHIS ZOO

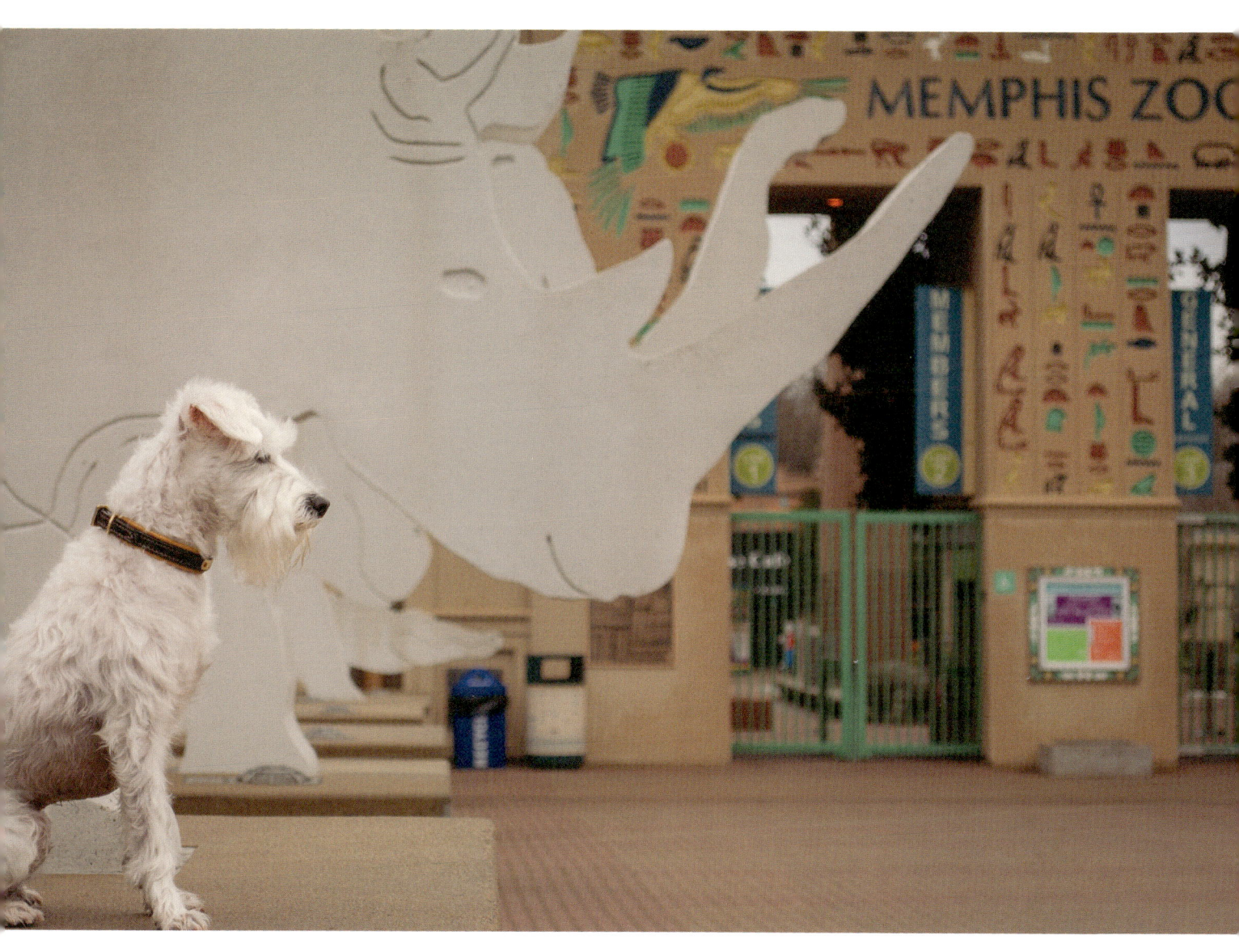

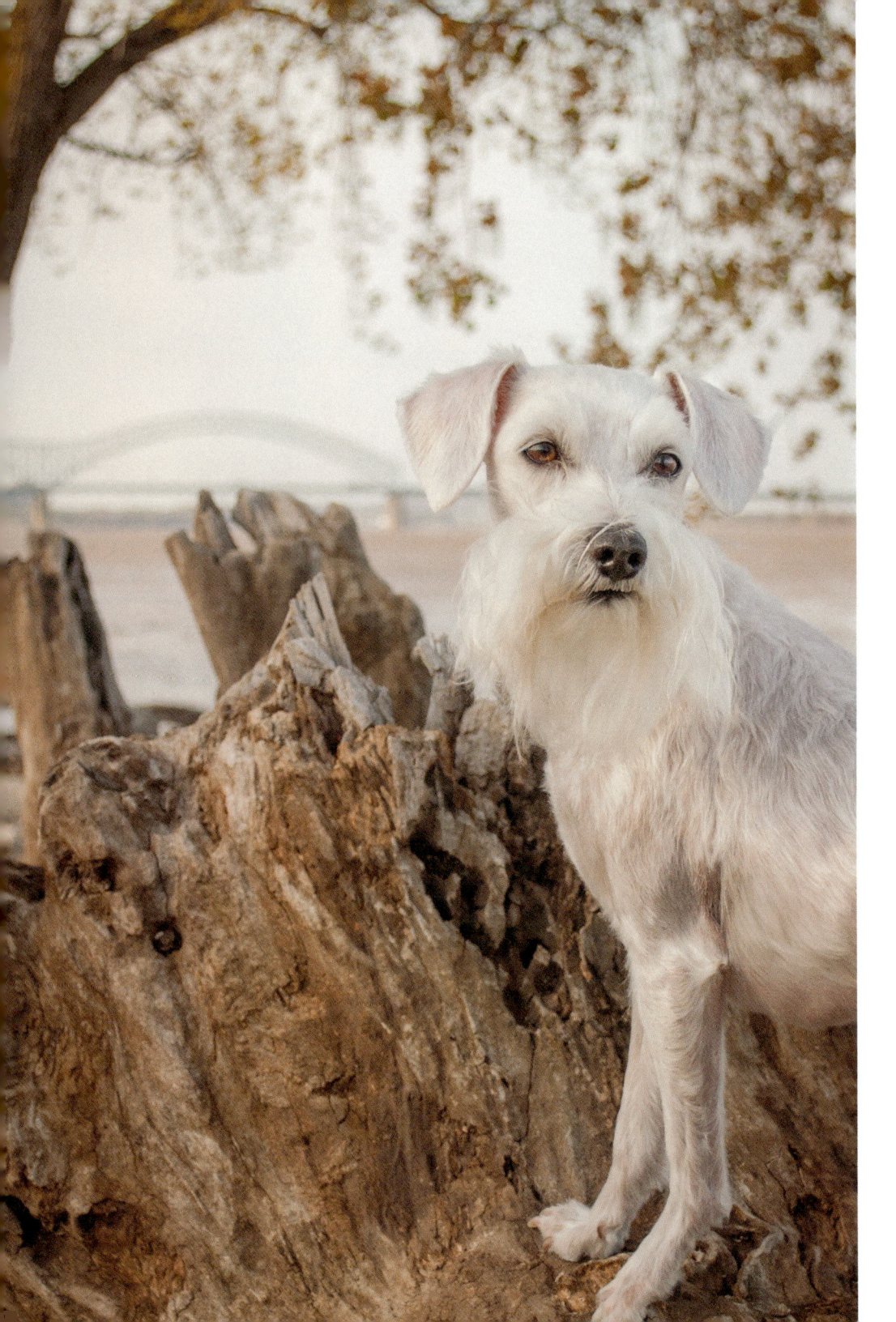

Week Seven

MISSISSIPPI GREENBELT PARK

Week Eight

ABSTRACT LOVE MURAL
CORNER OF AVALON AND MADISON

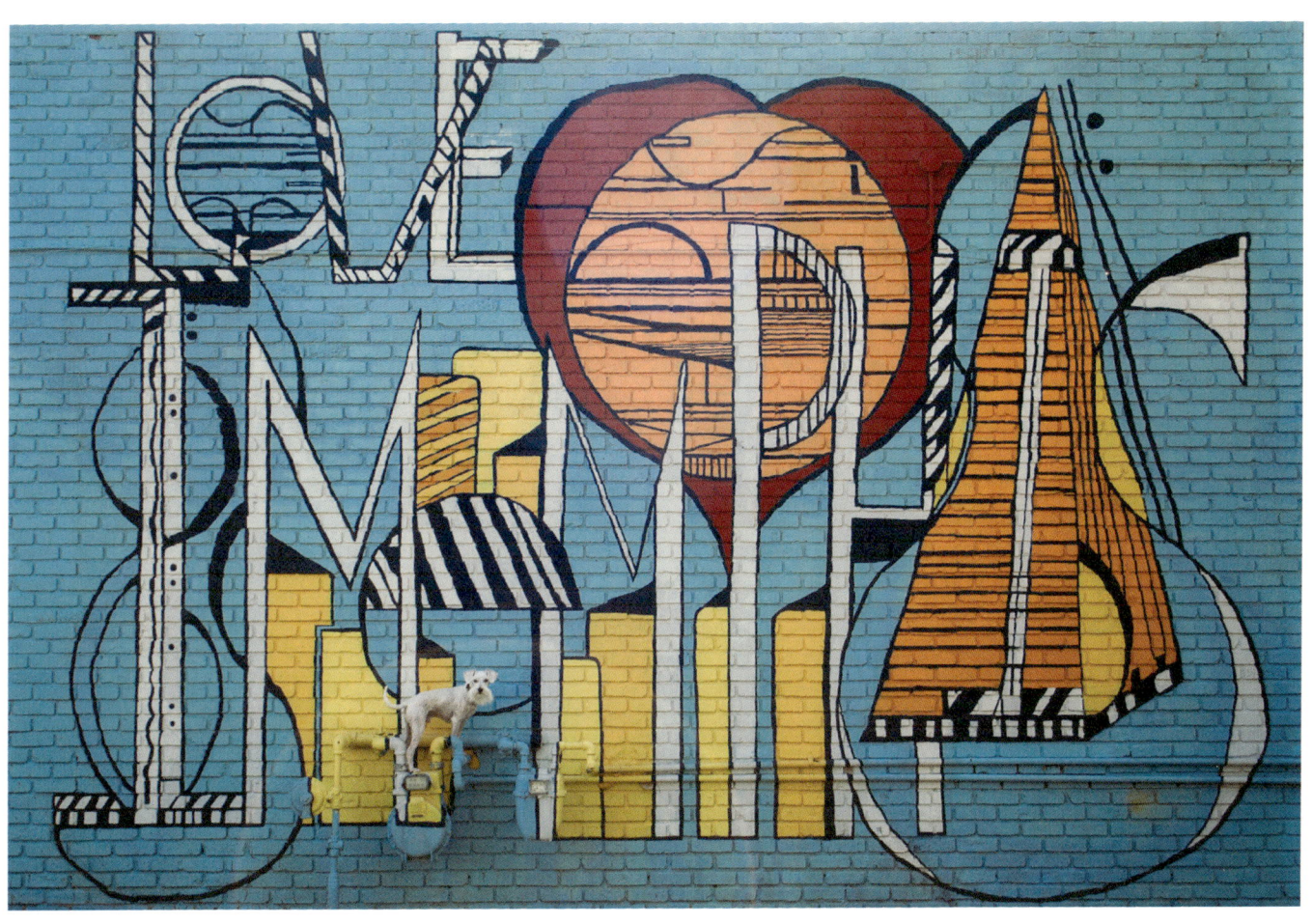

Week Nine

SHELBY FARMS GREENLINE
AT N. HIGHLAND ST.

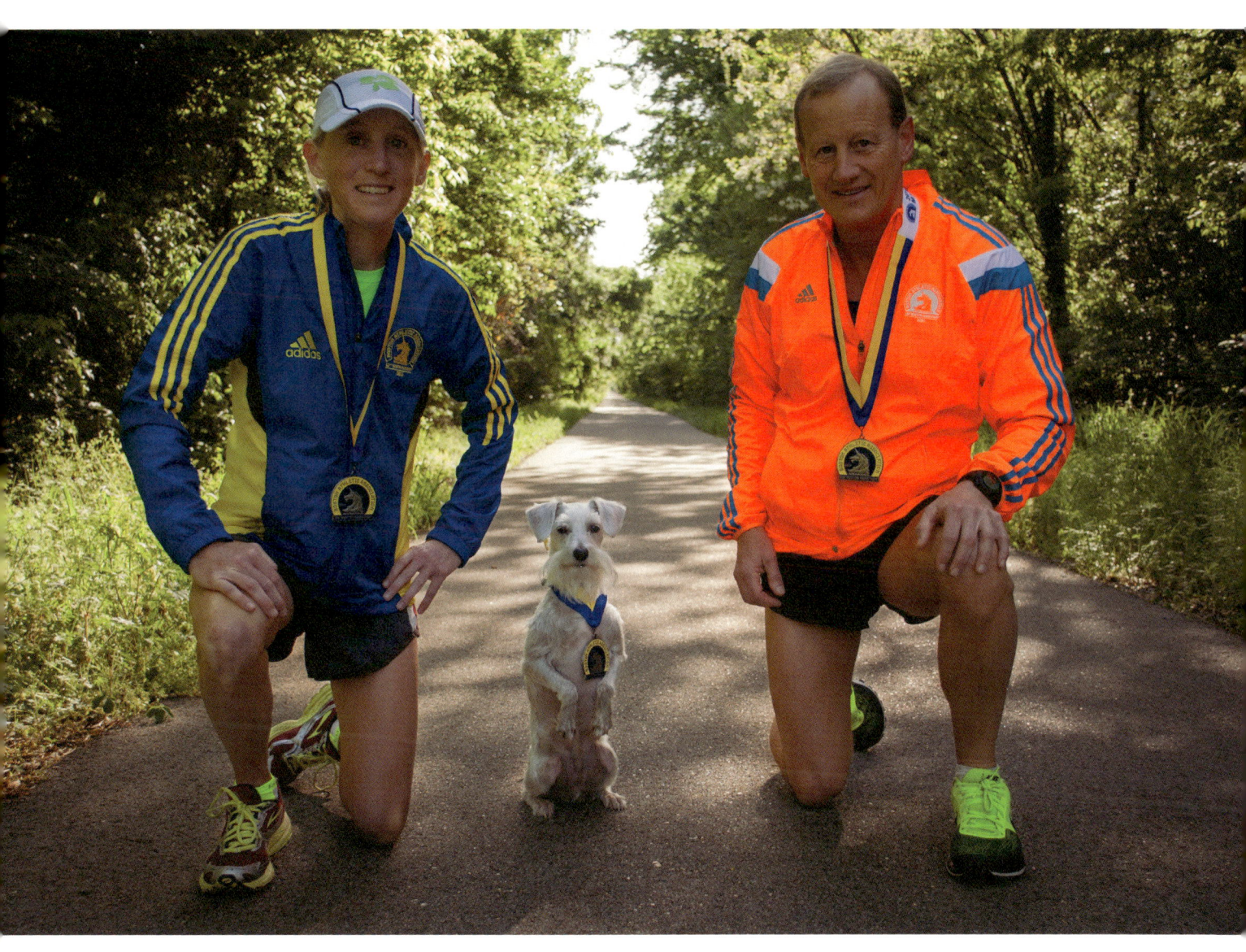

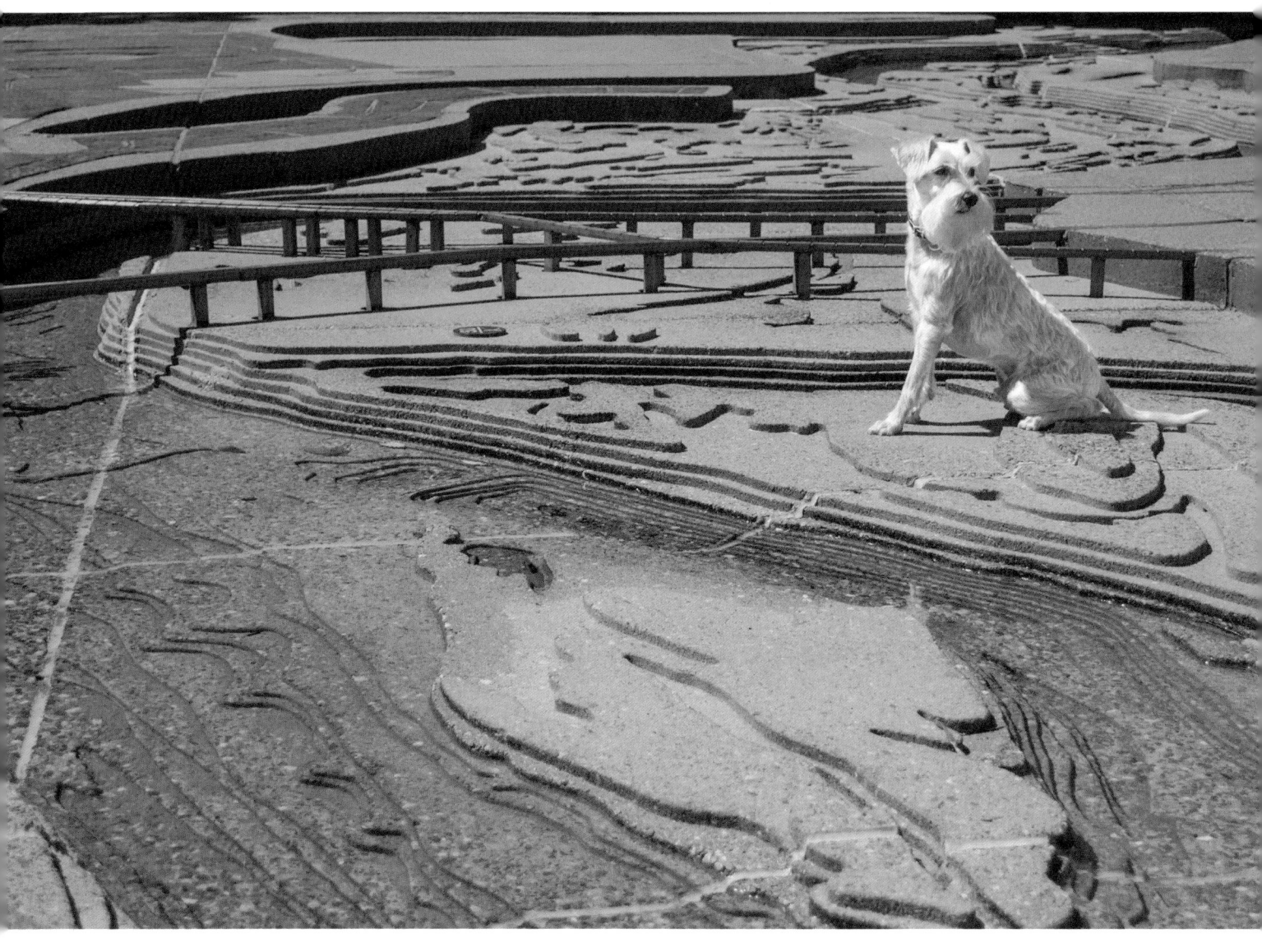

Week Ten

MUD ISLAND RIVER PARK

Week Eleven

BEFORE I DIE MURAL
AT JERRY'S SNO CONES

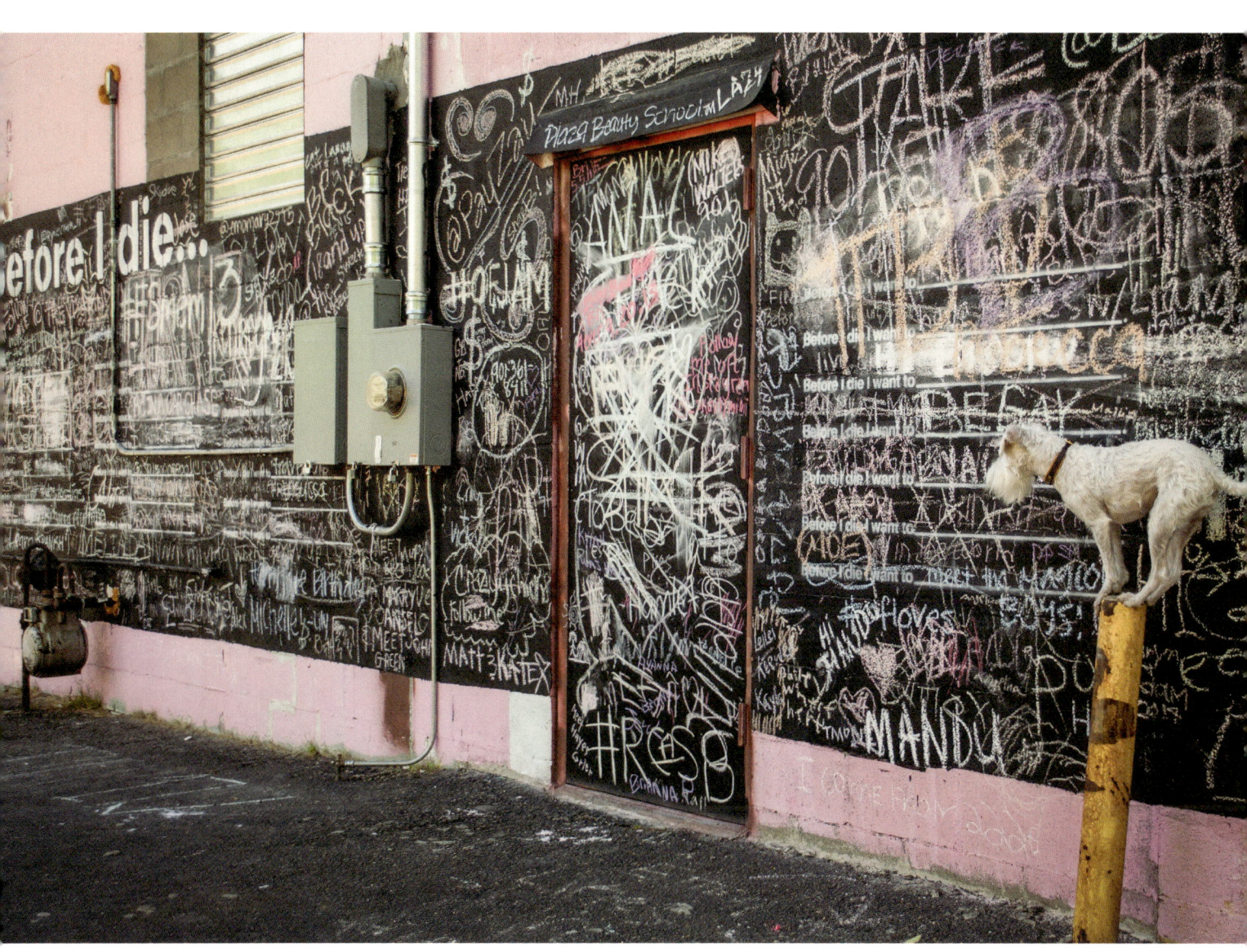

Week Twelve

BEALE ST.

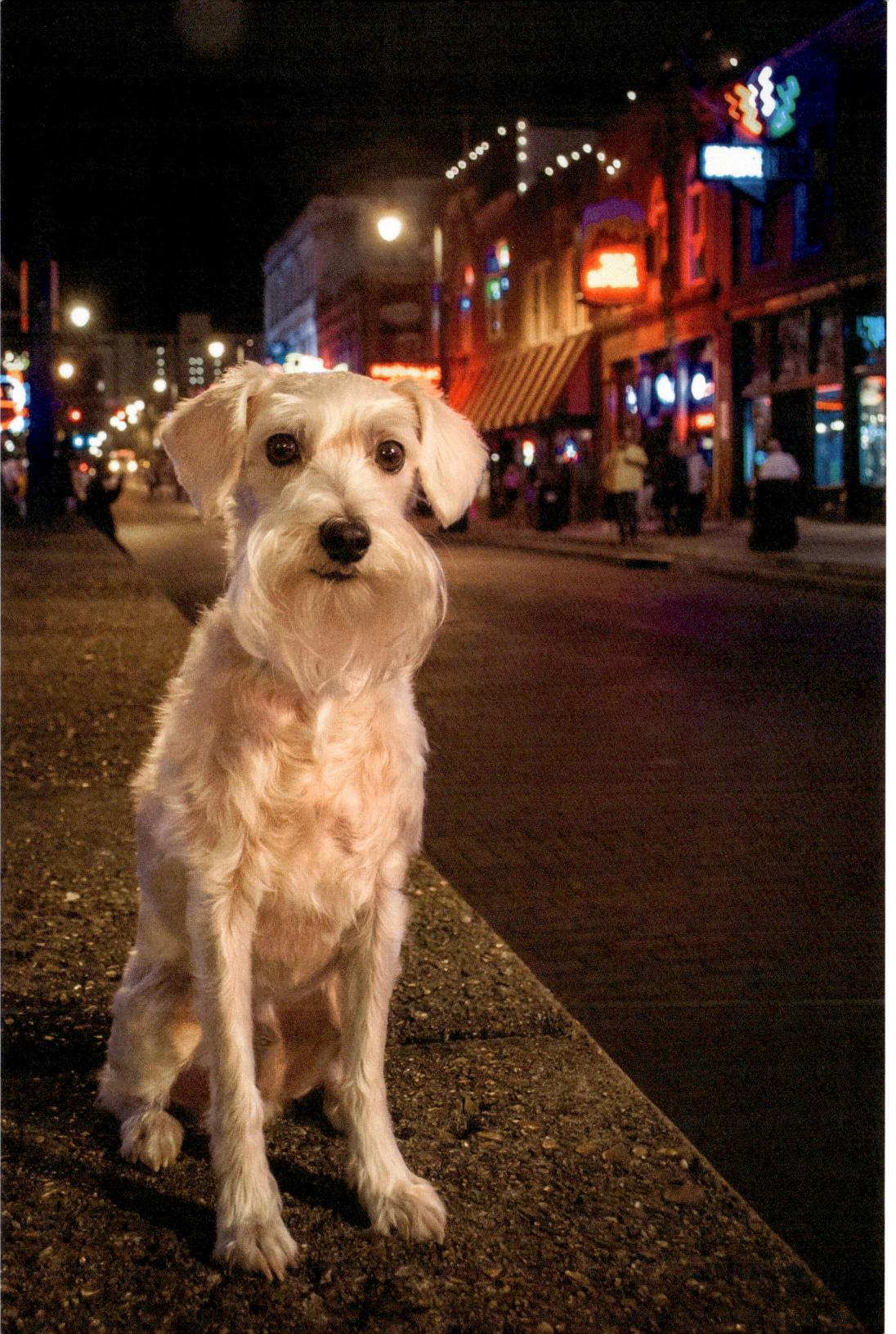

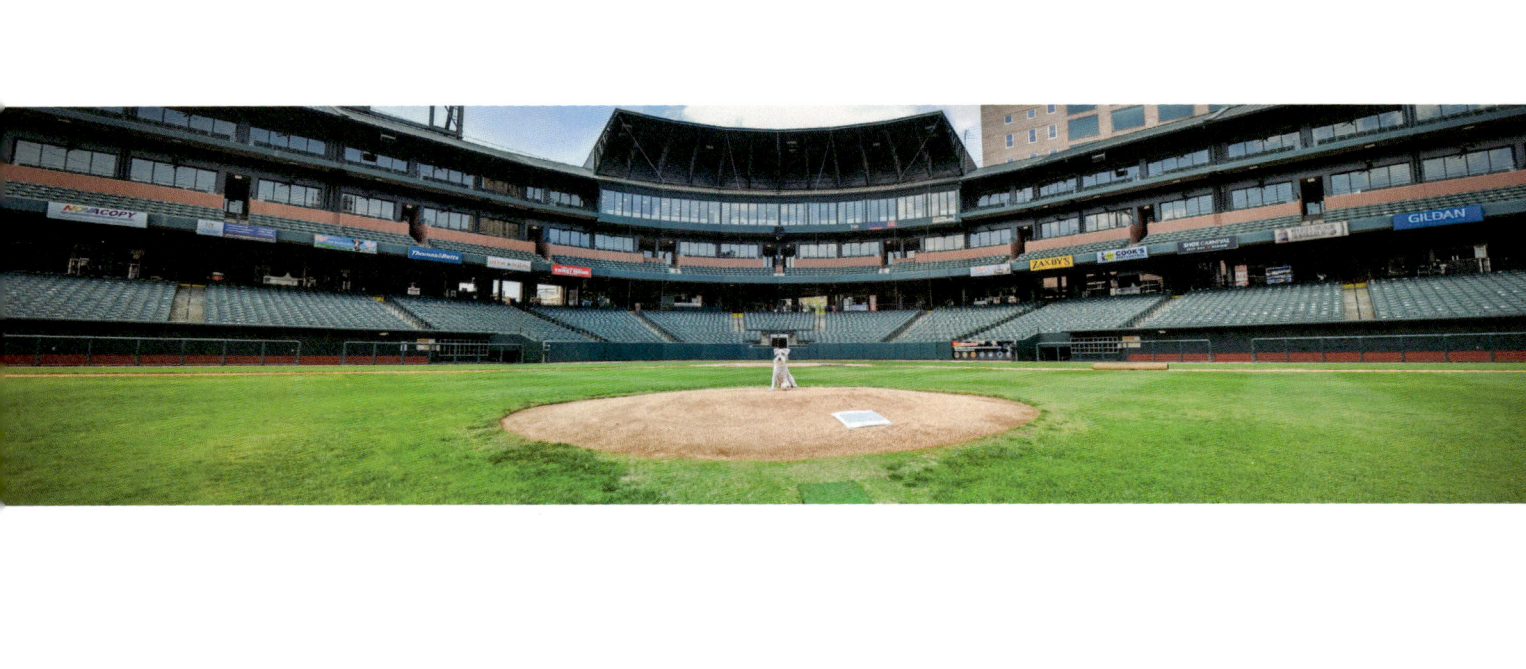

Week Thirteen

AUTOZONE PARK

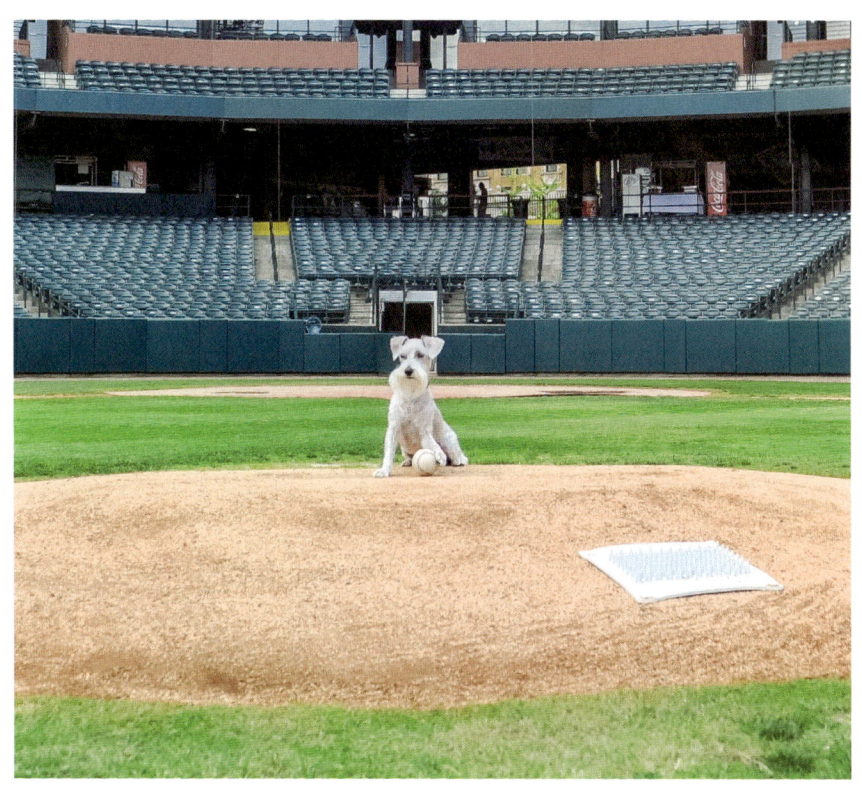

Week Fourteen

I ♥ MEMPHIS MURAL
COOPER ST. AND YORK AVE.

Week Fifteen

MEMPHIS PIZZA CAFE
OVERTON SQUARE LOCATION

Week Sixteen

TENNESSEE BREWERY

Week Seventeen

THE BADDEST MURAL
E. MCLEMORE AVE. AND MISSISSIPPI BLVD.

Week Eighteen

M FLOWERBED
1 EAST PARKWAY

Week Nineteen

ROOF LIKE FLUID FLUNG OVER THE PLAZA SCULPTURE
CANNON CENTER FOR THE PERFORMING ARTS

Week Twenty

THE PEABODY HOTEL

Week Twenty-One

THE LIBERTY BOWL

Week Twenty-Two

MARTYR'S PARK

Week Twenty-Three

BEALE ST. LANDING

Week Twenty-Four

PARK ADAMS APARTMENTS
NEXT TO MOLLIE FONTAINE LOUNGE

Week Twenty-Five

SUN STUDIO

Week Twenty-Six

SPRING, SUMMER, FALL SCULPTURE
MEMPHIS BROOKS MUSEUM

SPRING SUMMER FALL

Week Twenty-Seven

WOLF RIVER TRAILS
AT LUCIUS BURCH NATURAL AREA GATEWAY

Week Twenty-Eight

UNIVERSITY OF MEMPHIS

Week Twenty-Nine

PINK PALACE MUSEUM

Week Thirty

BENJAMIN L. HOOKS CENTRAL LIBRARY

Week Thirty-One

NATIONAL ORNAMENTAL METAL MUSEUM

Week Thirty-Two

BROAD AVE. ARTS DISTRICT

Week Thirty-Three

TREE OF LIFE MOSAIC
CANCER SURVIVORS PARK

Week Thirty-Four

OVERTON BARK DOG PARK

Week Thirty-Five

STAX MUSEUM OF AMERICAN SOUL MUSIC

Week Thirty-Six

MEMPHIS BOTANIC GARDEN

Week Thirty-Seven

SHELBY COUNTY COURTHOUSE

Week Thirty-Eight

THE BOOKSELLERS AT LAURELWOOD

Week Thirty-Nine

THE GRINDHOUSE

Week Forty

OVERTON SQUARE - REDUX MURAL

Week Forty-One

THE ORPHEUM THEATRE

Week Forty-Two

COOPER-YOUNG TRESTLE

Week Forty-Three

ELVIS PRESLEY'S GRACELAND

Week Forty-Four

LOVE IN RED MURAL
ALLEN ST. AND E. BUTLER AVE.

Week Forty-Five

THE CHILDREN'S MUSEUM OF MEMPHIS

Week Forty-Six

AMURICA PHOTO BOOTH

Week Forty-Seven

MUDDY'S BAKE SHOP

Week Forty-Eight

NATIONAL CIVIL RIGHTS MUSEUM

Week Forty-Nine

MALLORY-NEELY HOUSE

Week Fifty

CHOOSE 901 OFFICES

NOW IS THE TIME. MEMPHIS IS THE PLACE.

Week Fifty-One

SHELBY FARMS PARK

Week Fifty-Two

TART

Kathryn Willis grew up in rural New York where she earned a B.S. in Theater Arts Management from Ithaca College. She moved to Memphis in 2010 where she decided instead to pursue her passion for animals and started a career in the veterinary field. When she isn't helping pets in the animal hospital, she's usually out exploring Memphis and photographing her dog, Loki. In addition to the work she does as a professional photographer, she also volunteers her photography skills for animal rescue groups, helping to bring attention to other rescue pets in need of homes.

To view more of her work, visit kathrynwillisphotography.com

CPSIA information can be obtained
at www.ICGtesting.com
Printed in the USA
LVIC06n1312081215
465946LV00001B/1